DATE DUE

Adventures of
Rusty & Ginger Fox

Adventures of Rusty & Ginger Fox
Published by Synergy Books
P.O. Box 30071
Austin, TX 78755

For more information about our books, please write us, e-mail us at info@synergybooks.net, or visit our web site at www.synergybooks.net.

Publisher's Cataloging-in-Publication
(Provided by Quality Books, Inc.)

Ostermeyer, Tim.
 Adventures of Rusty & Ginger Fox / by Tim Ostermeyer.
 p. cm.
 SUMMARY: As two young foxes set out to explore the
forest, they encounter all kinds of wild creatures:
bears, bobcats, cougars, and wolves. Then they discover
an island with treasure and two little girls who may be
friends or foes. Includes wildlife photography and facts
about foxes and each animal they meet.
 Audience: Ages 4-8.
 LCCN 2010925621
 ISBN-13: 978-0-9845040-0-8
 ISBN-10: 0-9845040-0-1

 1. Foxes--Juvenile fiction. 2. Animals--Juvenile
fiction. [1. Foxes--Fiction. 2. Animals--Fiction.
 I. Title. II. Title: Adventures of Rusty and Ginger Fox.

 PZ7.O8456Adv 2010 [E]
 QBI10-600084

10 9 8 7 6 5 4 3 2 1

Adventures of
Rusty & Ginger
Fox

By Master Photographer
&
Author
Tim Ostermeyer

Synergy Books

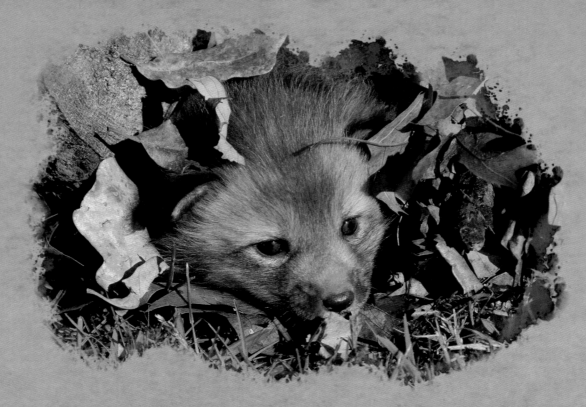

Deep in the forest, there lives a family of friendly foxes. Ginger and Rusty are Red Foxes, but at two weeks old, they still have brown fur. Until they get a little bigger, Rusty and Ginger must stay in their log, where their parents can protect them.

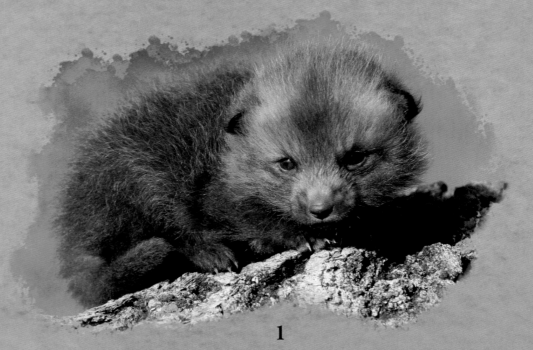

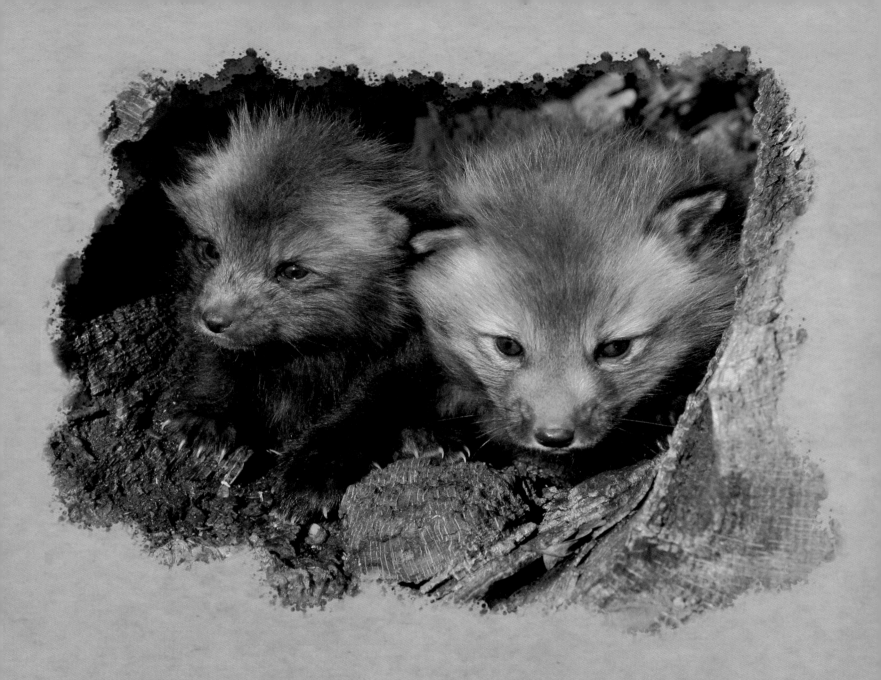

They love to hear the stories Mom and Dad
tell them about the forest and the
animals that live in it.

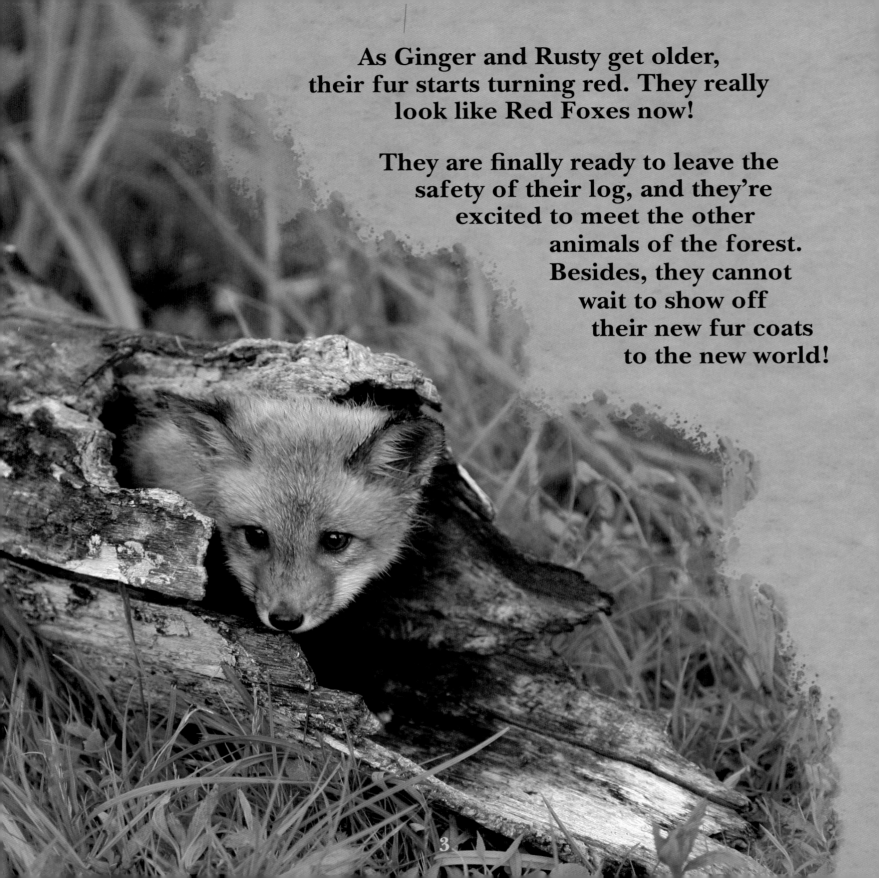

As Ginger and Rusty get older, their fur starts turning red. They really look like Red Foxes now!

They are finally ready to leave the safety of their log, and they're excited to meet the other animals of the forest. Besides, they cannot wait to show off their new fur coats to the new world!

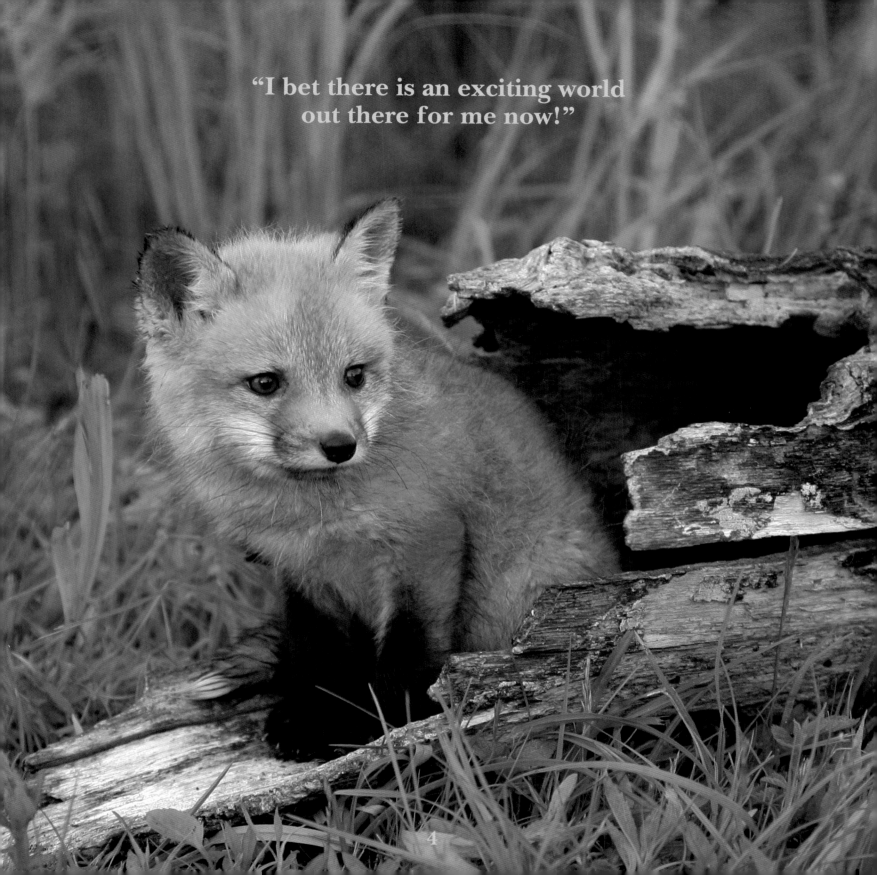

"I bet there is an exciting world
out there for me now!"

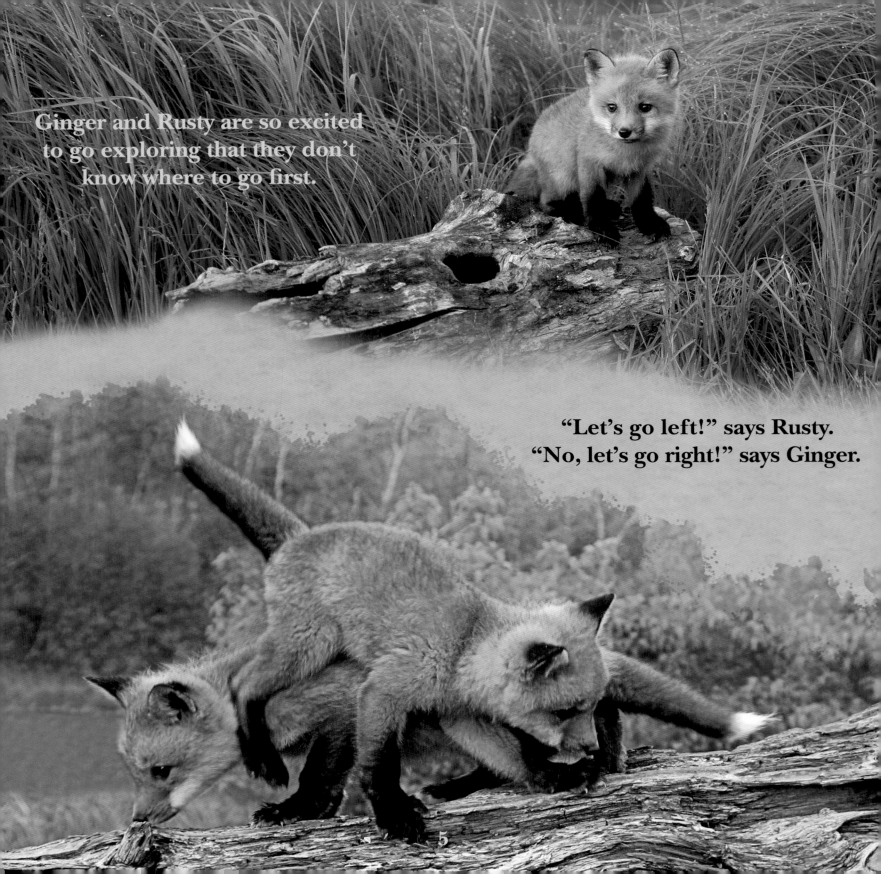

Ginger and Rusty are so excited to go exploring that they don't know where to go first.

"Let's go left!" says Rusty.
"No, let's go right!" says Ginger.

5

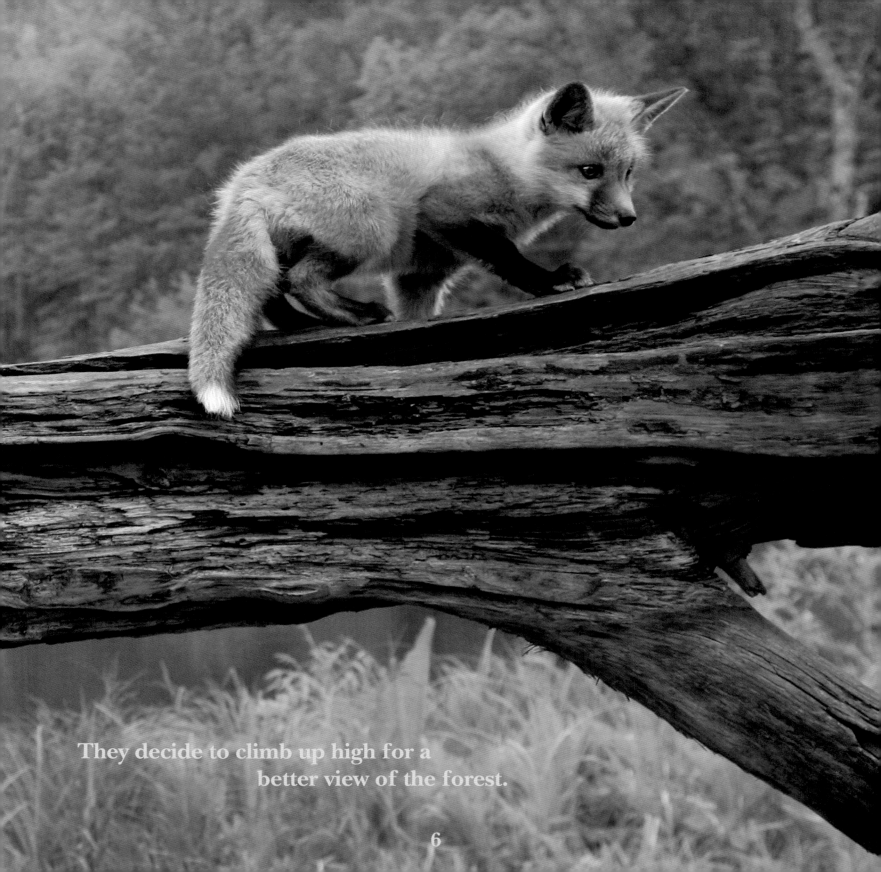

They decide to climb up high for a
 better view of the forest.

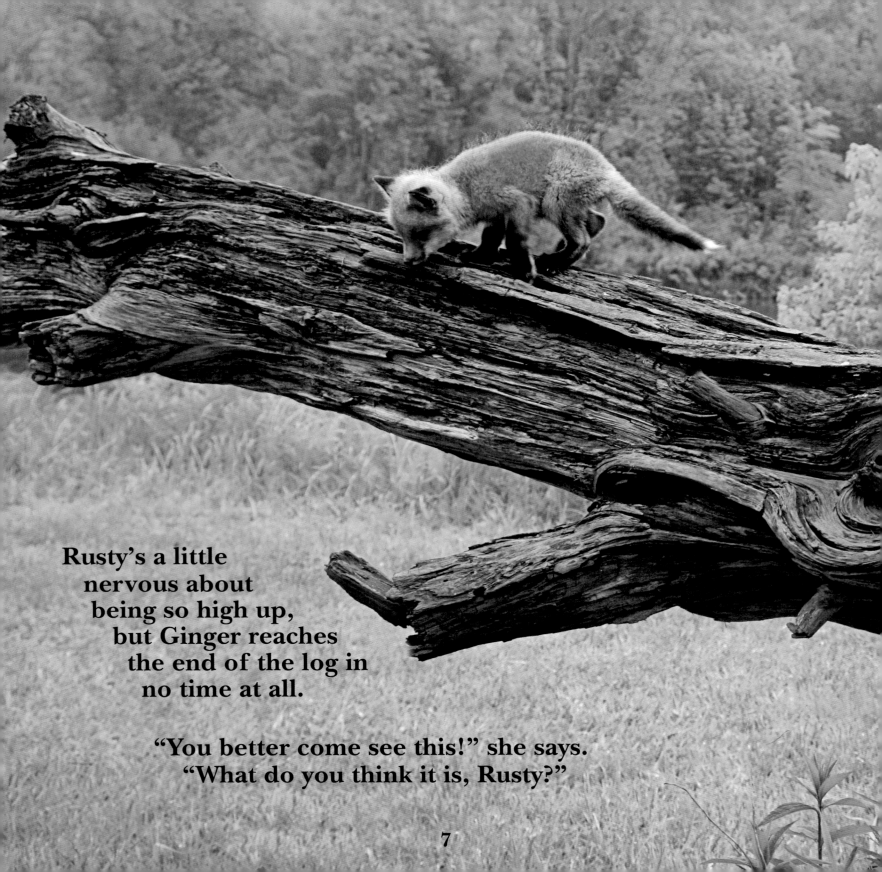

Rusty's a little
nervous about
being so high up,
but Ginger reaches
the end of the log in
no time at all.

"You better come see this!" she says.
"What do you think it is, Rusty?"

7

Did you know that Foxes...

Use their tails
for warmth

Have 18-inch tails

Grow more fur in fall
and winter for warmth

Can run 45 mph

Have 2–8
baby kits in spring

Have white tips
on their tails

Weigh 8–15 pounds

Stalk prey like a cat

Use small den
for food and large
den for warmth

Have black legs,
black ears,
and white bellies

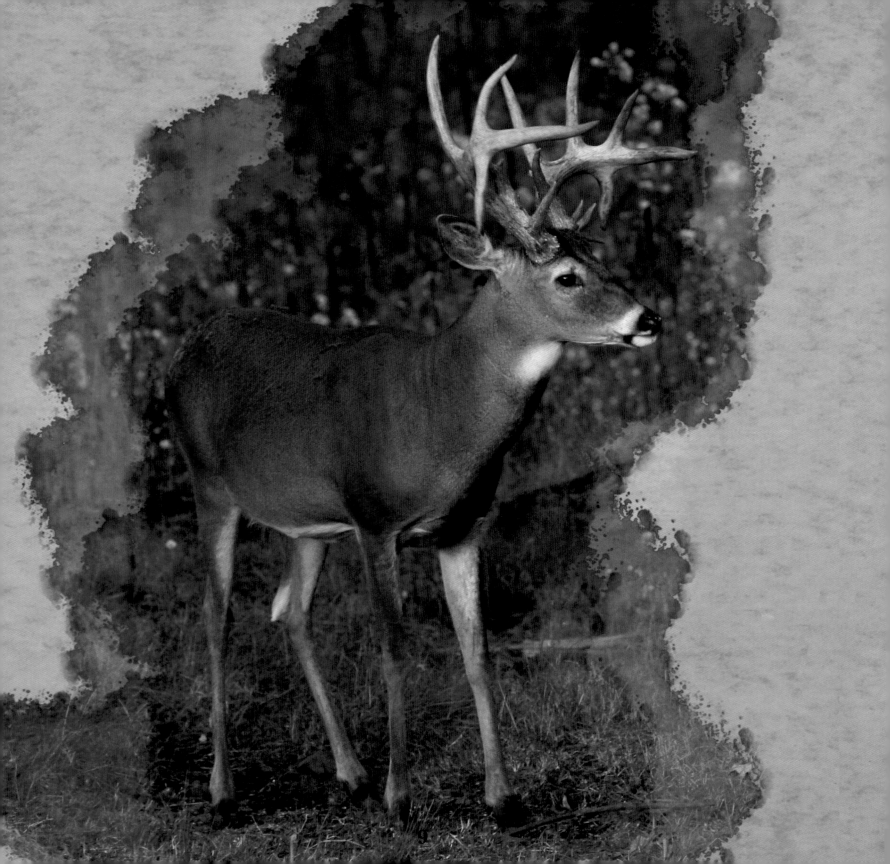

Rusty noticed,
"Well, the grownup has big horns,
so they must be deer."

Did you know that Deer...

Eat leaves, grass
corn, cactus, and fruit

Weigh up to 300 pounds

Live up to 12 years if
not hunted or hit by car

Can jump 15 feet high

Lick their babies
to remove scent
and keep them safe

Are born with
spots for safety and
lose them in 3 months

Have special stomachs
that allow them to eat
poisonous mushrooms

Number about 30
million in America

Regrow antlers
each year

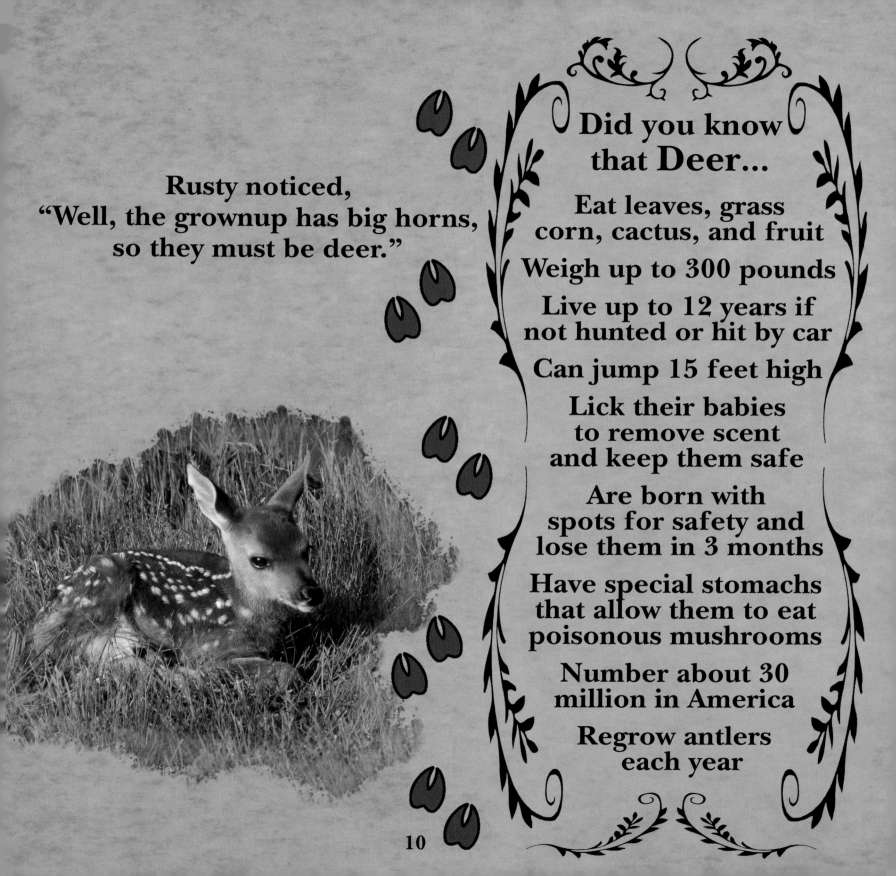

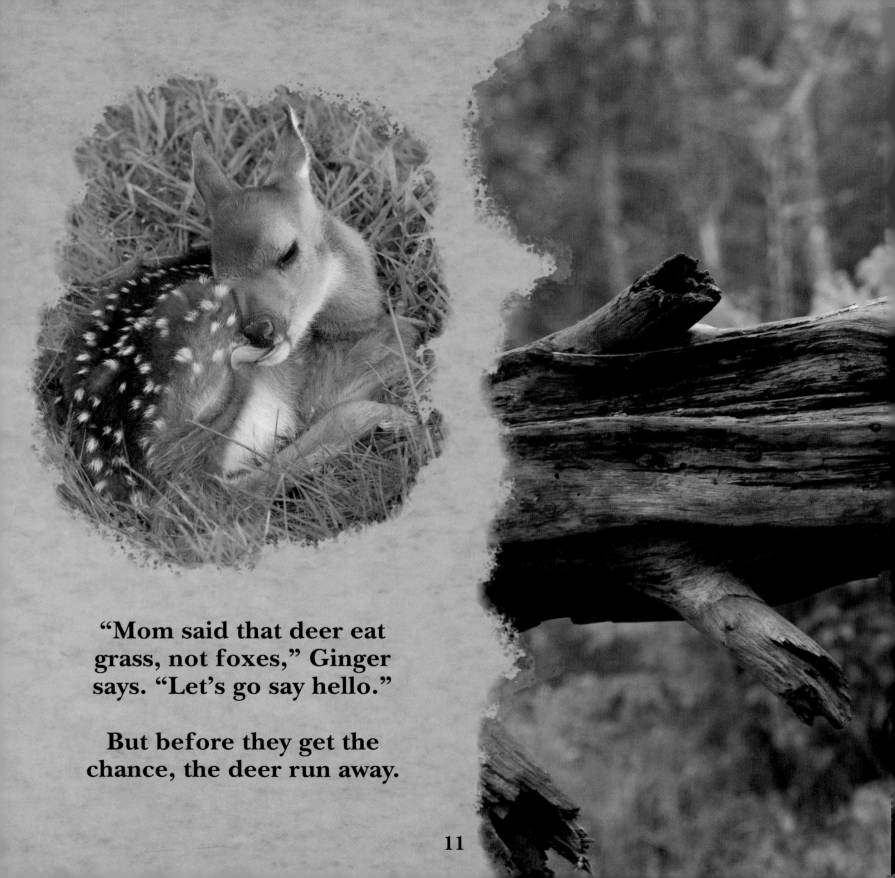

"Mom said that deer eat
grass, not foxes," Ginger
says. "Let's go say hello."

But before they get the
chance, the deer run away.

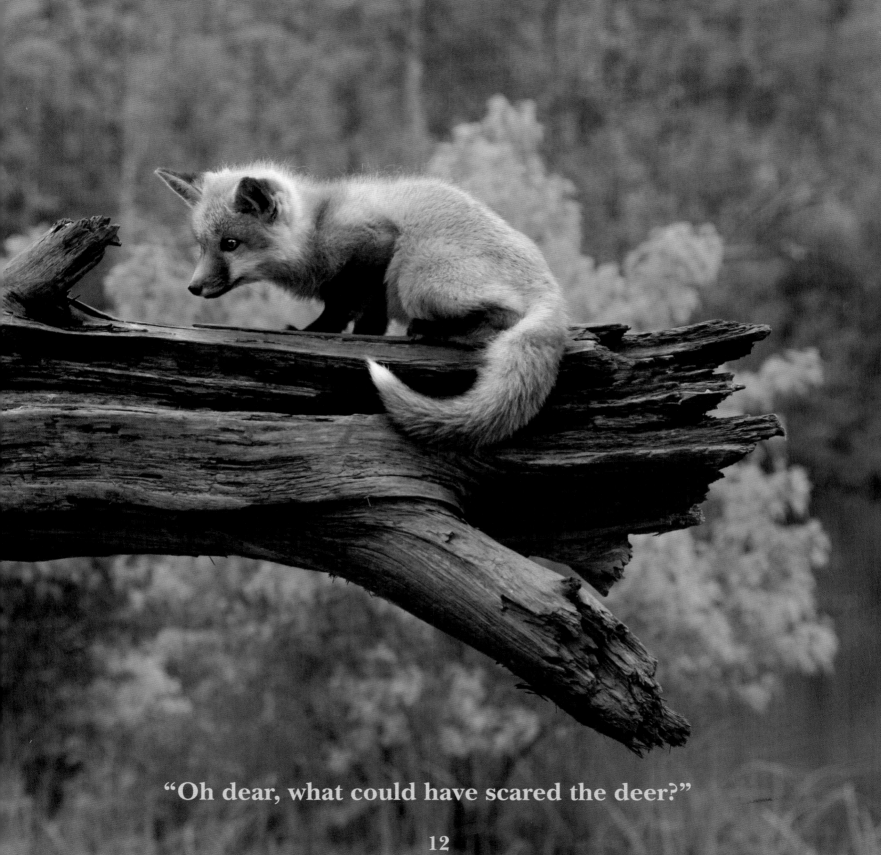

"Oh dear, what could have scared the deer?"

It's another animal, but this one doesn't look so friendly. "Sharp teeth, big ears, and a fluffy tail," whispers Rusty. "It's a wolf!"

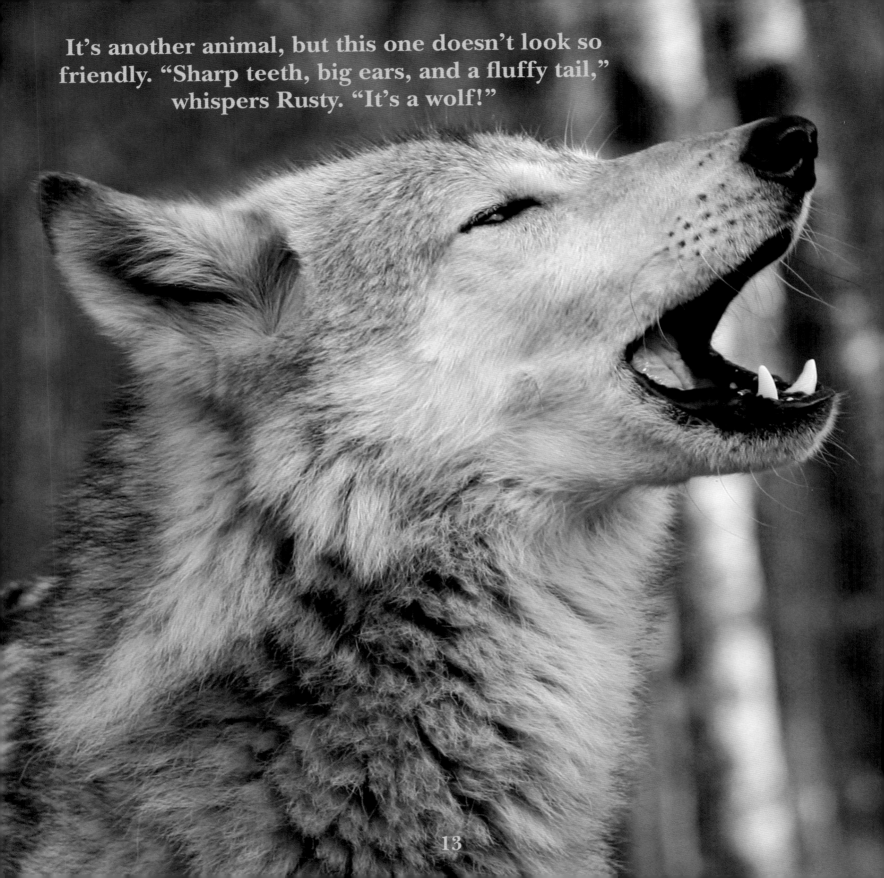

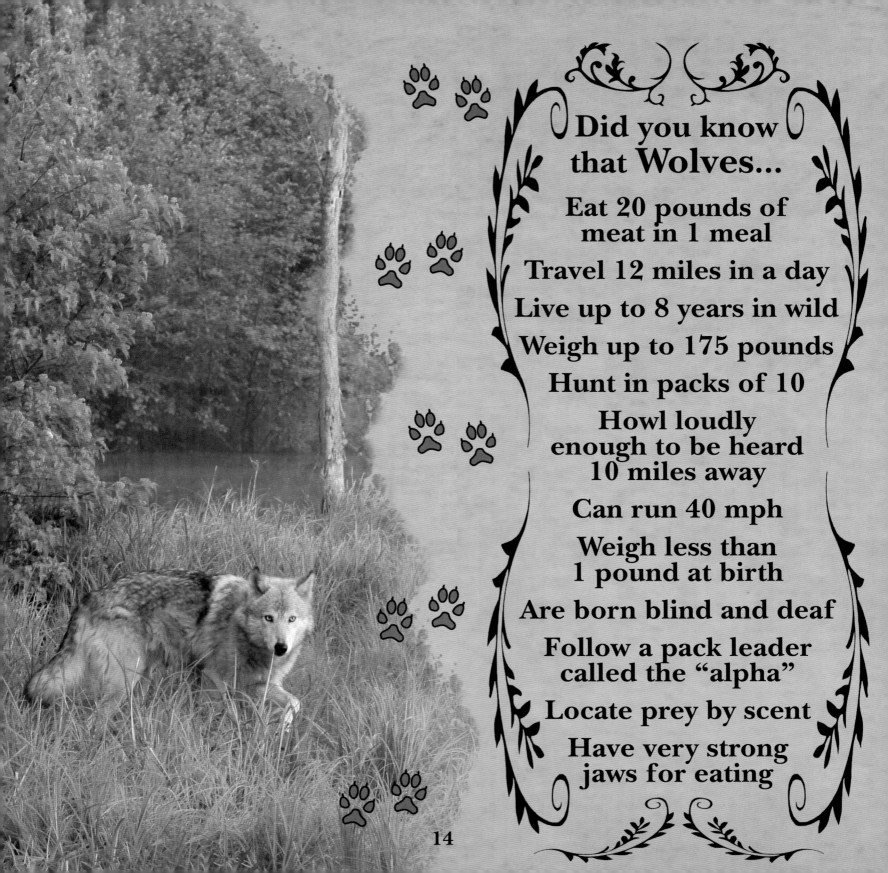

Did you know that Wolves...

Eat 20 pounds of meat in 1 meal

Travel 12 miles in a day

Live up to 8 years in wild

Weigh up to 175 pounds

Hunt in packs of 10

Howl loudly enough to be heard 10 miles away

Can run 40 mph

Weigh less than 1 pound at birth

Are born blind and deaf

Follow a pack leader called the "alpha"

Locate prey by scent

Have very strong jaws for eating

14

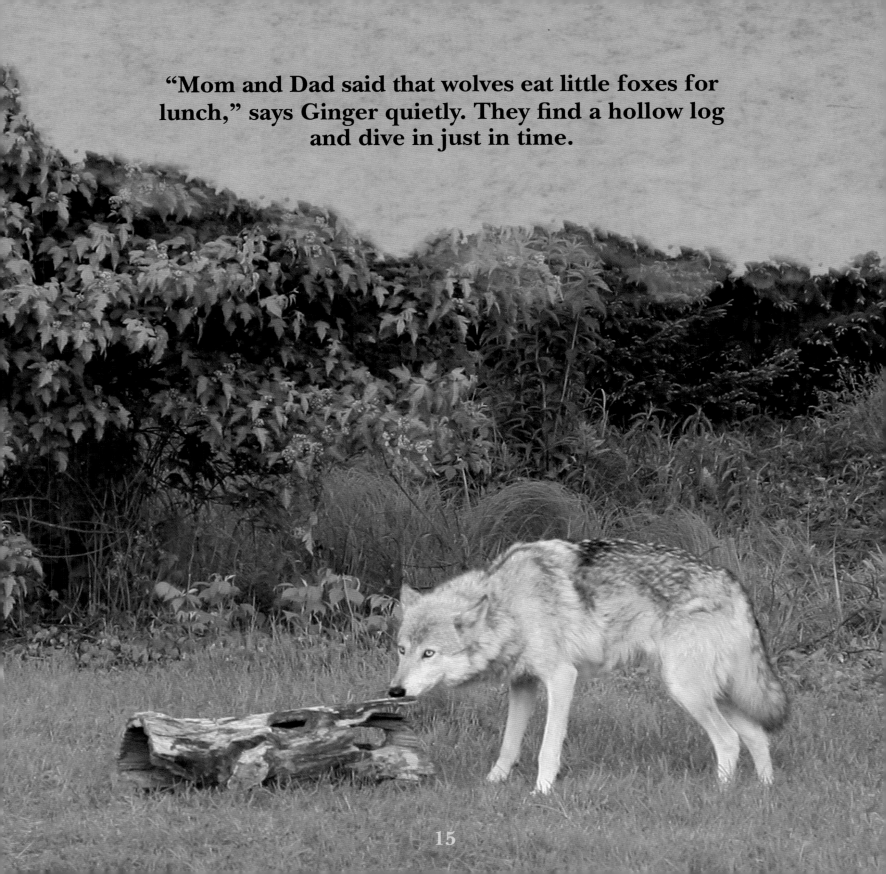

"Mom and Dad said that wolves eat little foxes for lunch," says Ginger quietly. They find a hollow log and dive in just in time.

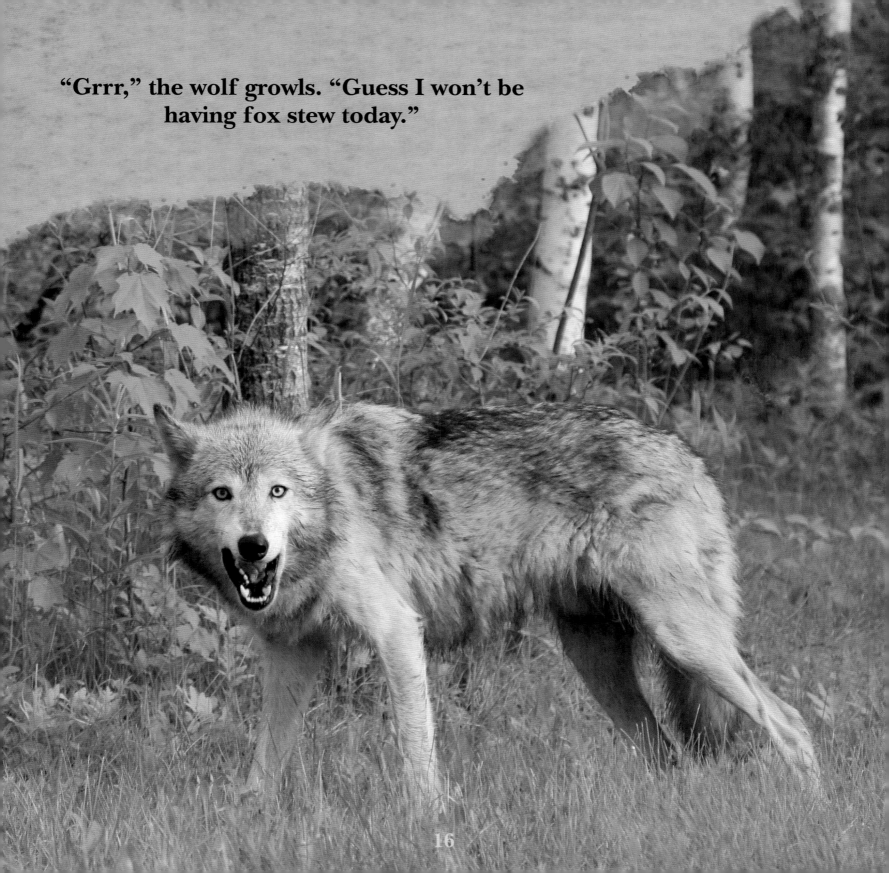

"Grrr," the wolf growls. "Guess I won't be having fox stew today."

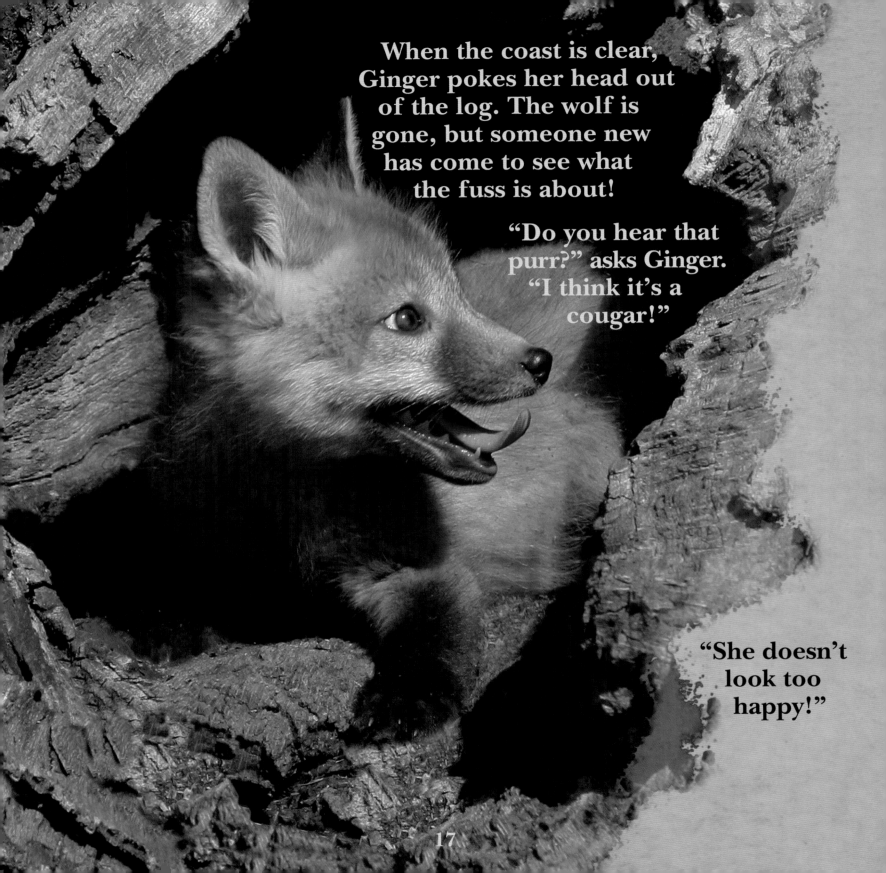

When the coast is clear, Ginger pokes her head out of the log. The wolf is gone, but someone new has come to see what the fuss is about!

"Do you hear that purr?" asks Ginger. "I think it's a cougar!"

"She doesn't look too happy!"

17

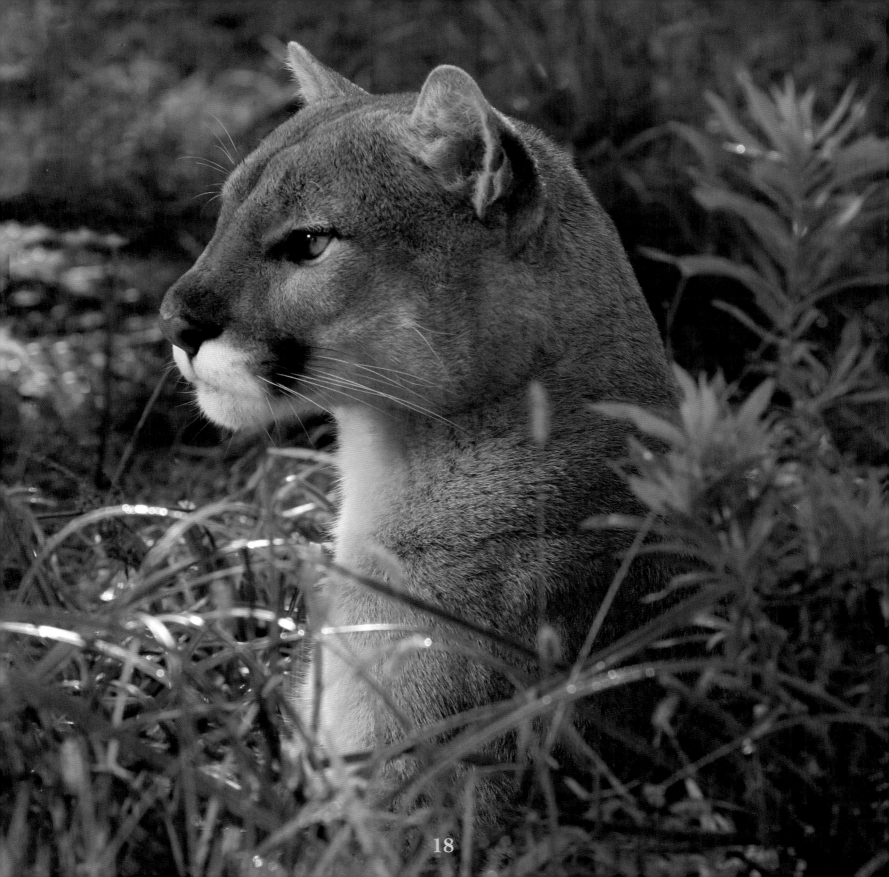

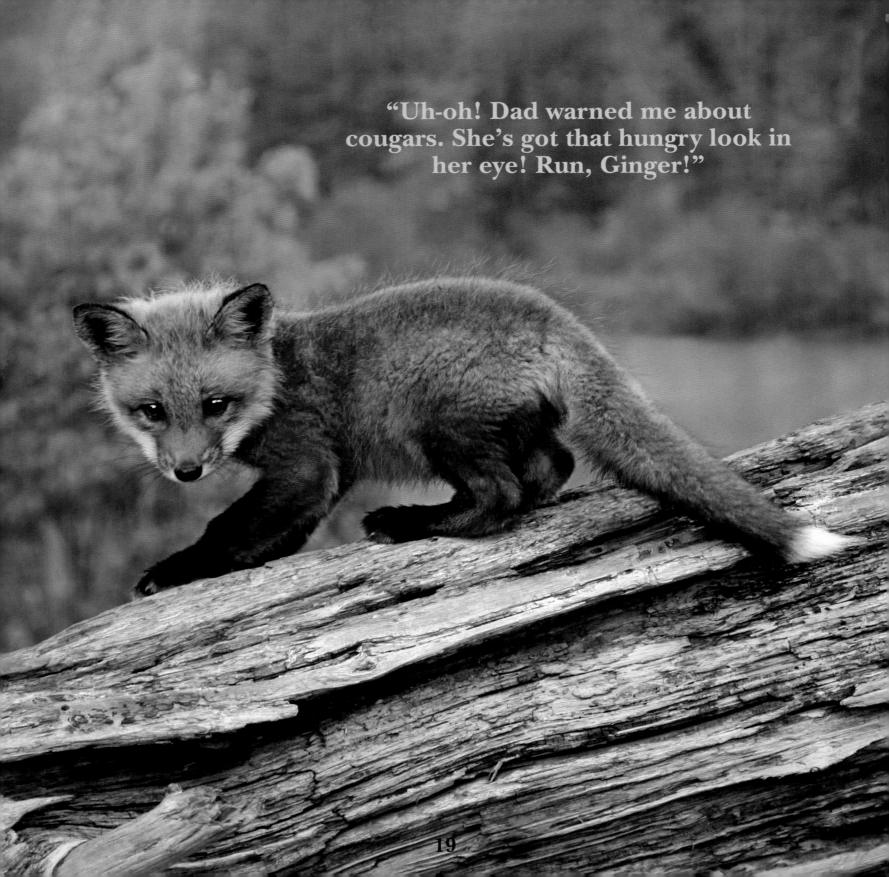

"Uh-oh! Dad warned me about cougars. She's got that hungry look in her eye! Run, Ginger!"

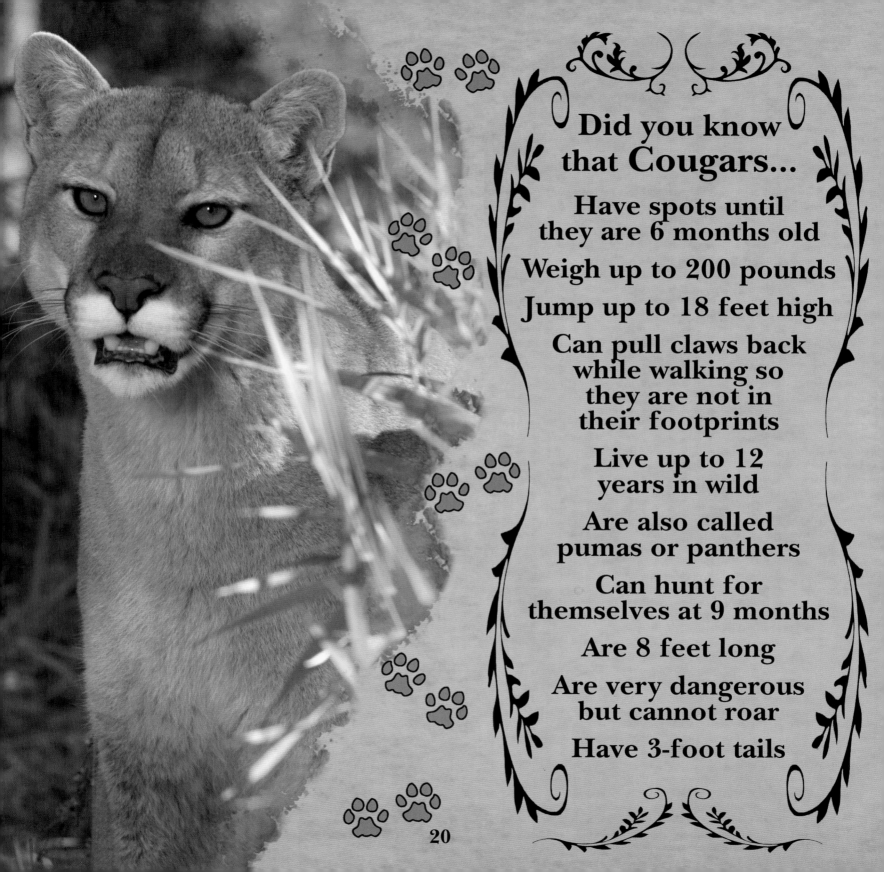

Did you know that Cougars...

Have spots until they are 6 months old

Weigh up to 200 pounds

Jump up to 18 feet high

Can pull claws back while walking so they are not in their footprints

Live up to 12 years in wild

Are also called pumas or panthers

Can hunt for themselves at 9 months

Are 8 feet long

Are very dangerous but cannot roar

Have 3-foot tails

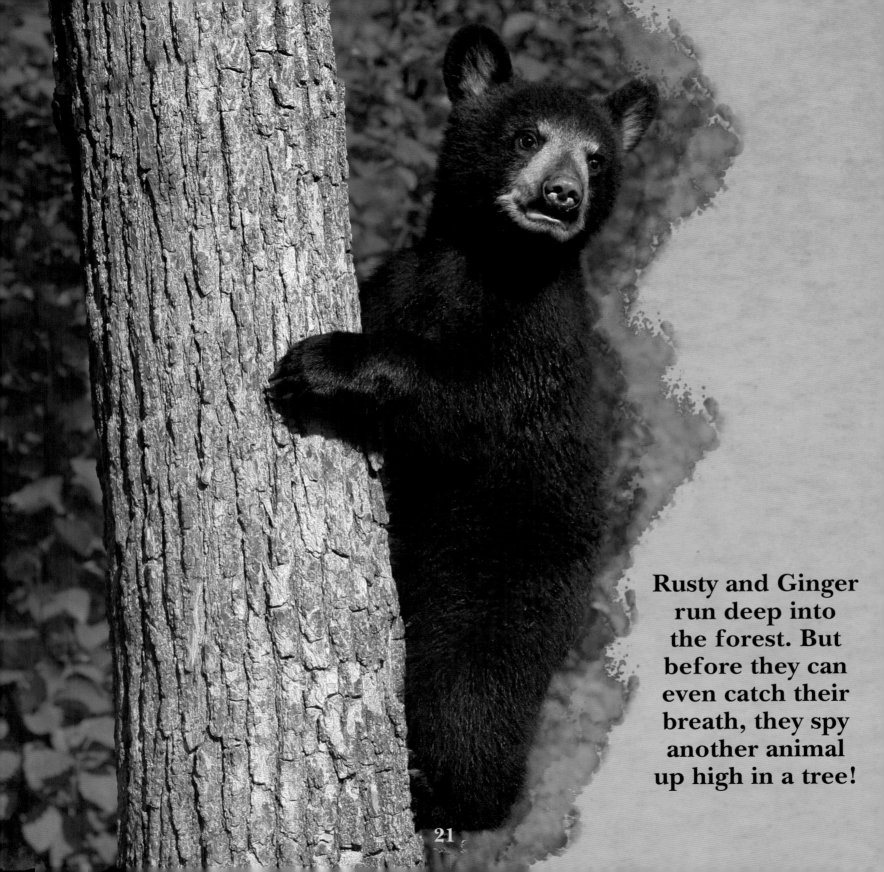

Rusty and Ginger run deep into the forest. But before they can even catch their breath, they spy another animal up high in a tree!

21

The animal
climbs down
and waves hello.
"Look at his black
fur and long,
sharp claws," says
Rusty. "It must be
a black bear!"

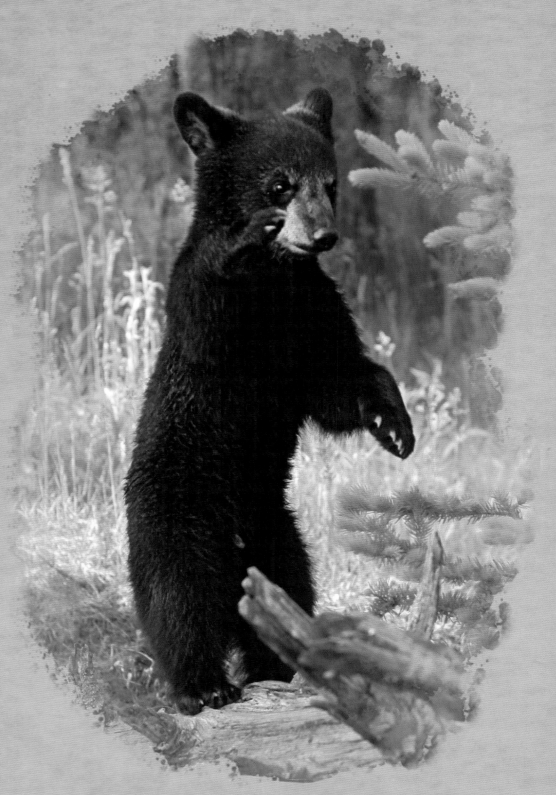

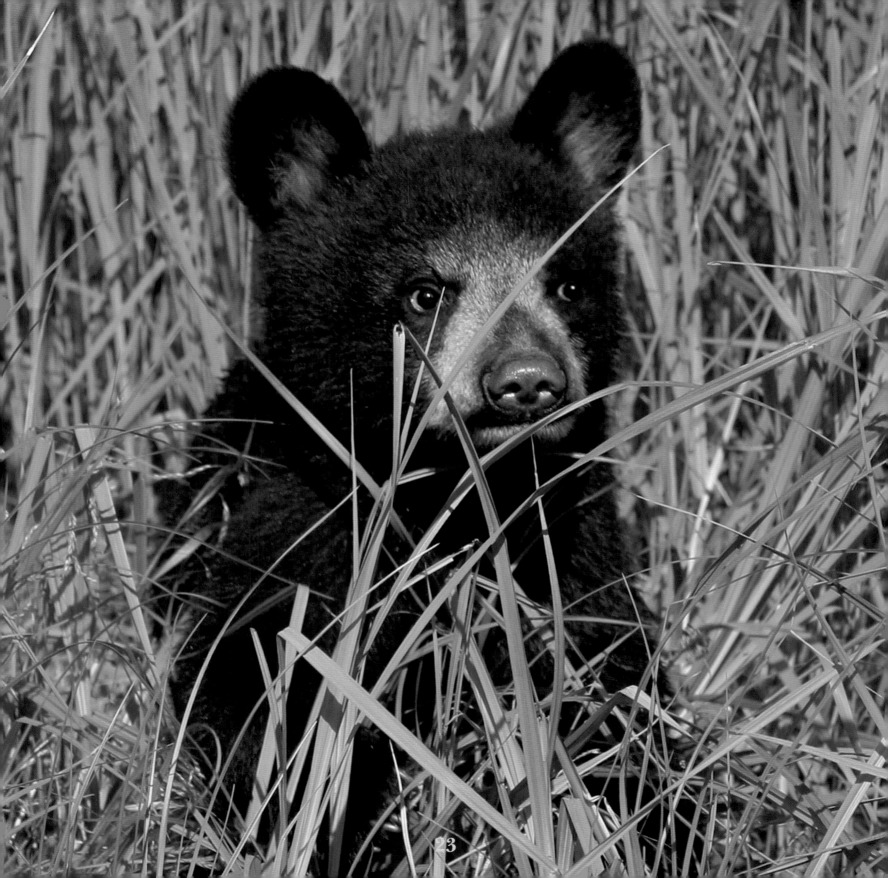

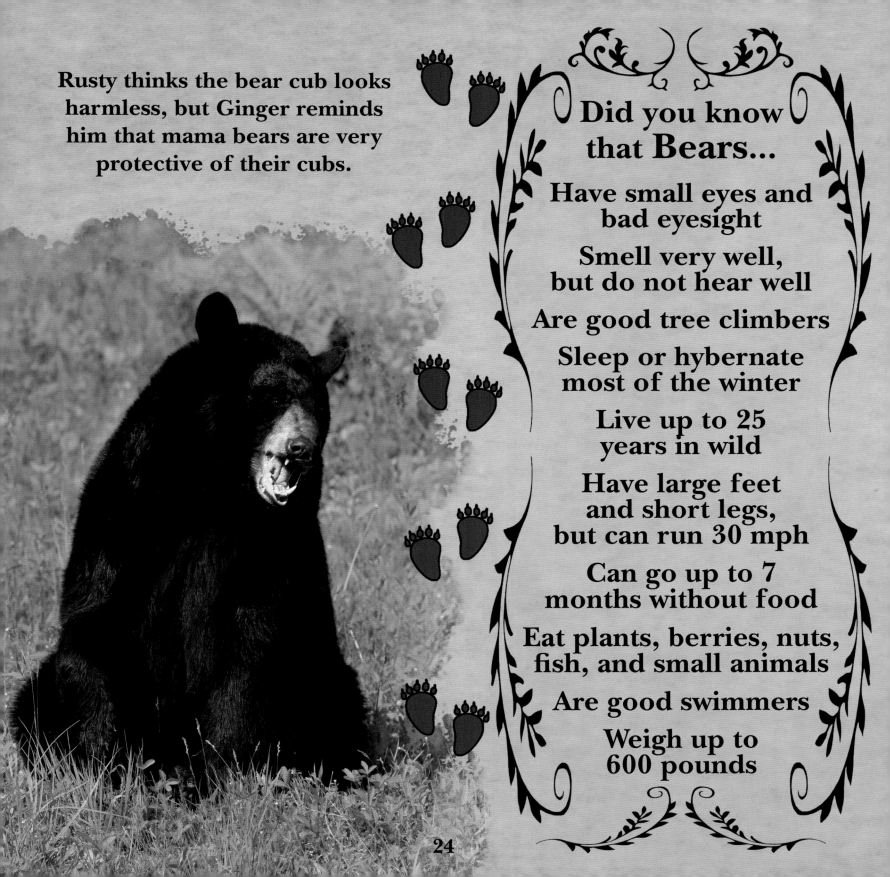

Rusty thinks the bear cub looks harmless, but Ginger reminds him that mama bears are very protective of their cubs.

Did you know that Bears...

Have small eyes and bad eyesight

Smell very well, but do not hear well

Are good tree climbers

Sleep or hybernate most of the winter

Live up to 25 years in wild

Have large feet and short legs, but can run 30 mph

Can go up to 7 months without food

Eat plants, berries, nuts, fish, and small animals

Are good swimmers

Weigh up to 600 pounds

Rusty and Ginger sneak away from the bears, but they're not out of danger yet. They see two little animals with pointy ears and whiskers.

"Oh, what adorable baby bobcats!" Ginger says.

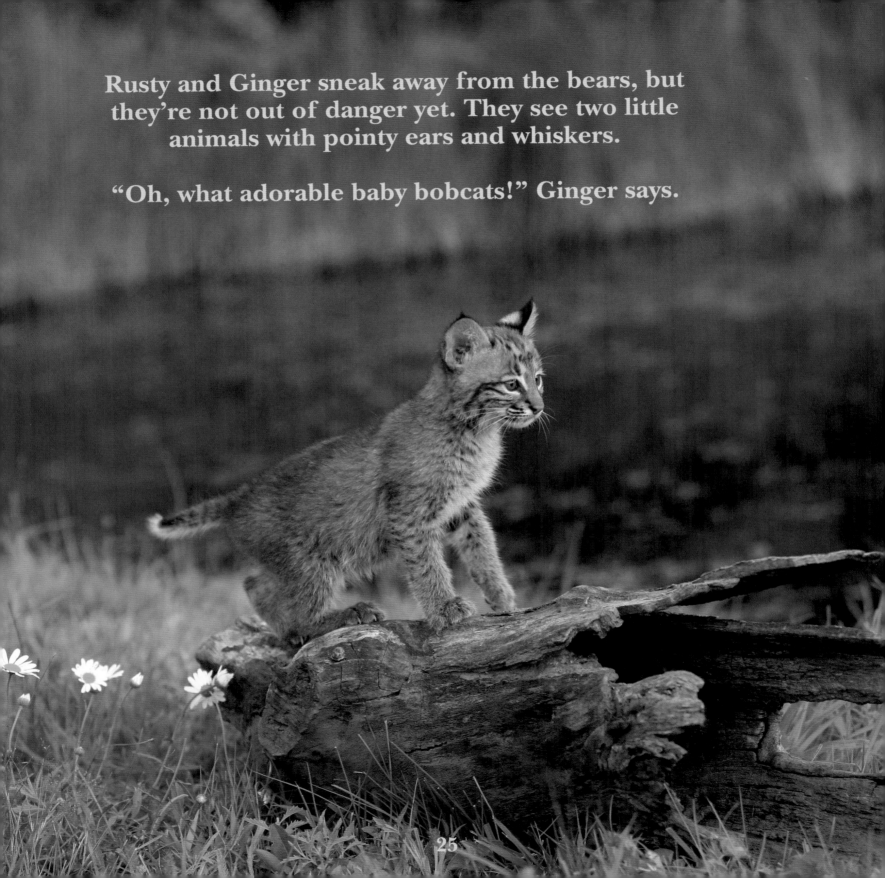

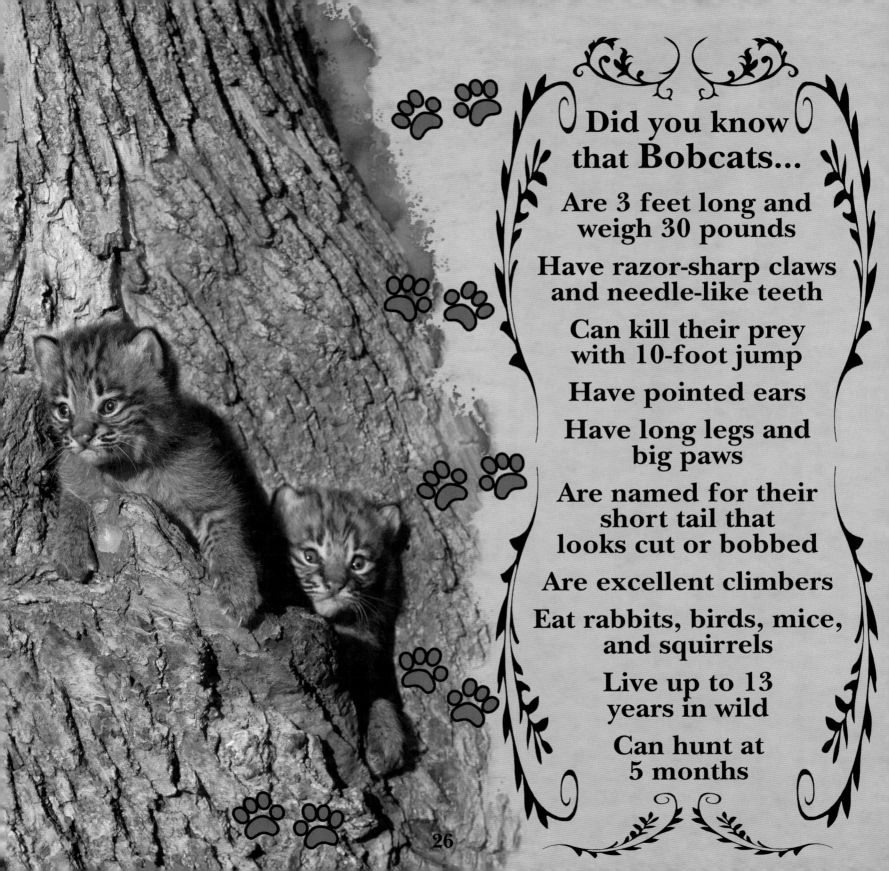

Did you know
that Bobcats...

Are 3 feet long and
weigh 30 pounds

Have razor-sharp claws
and needle-like teeth

Can kill their prey
with 10-foot jump

Have pointed ears

Have long legs and
big paws

Are named for their
short tail that
looks cut or bobbed

Are excellent climbers

Eat rabbits, birds, mice,
and squirrels

Live up to 13
years in wild

Can hunt at
5 months

But soon the daddy bobcat arrives
and roars at the two young foxes.
"I don't like the look of his
long teeth," Rusty says. "Let's get
out of here!" They run away as
fast as their little fox legs
can carry them.

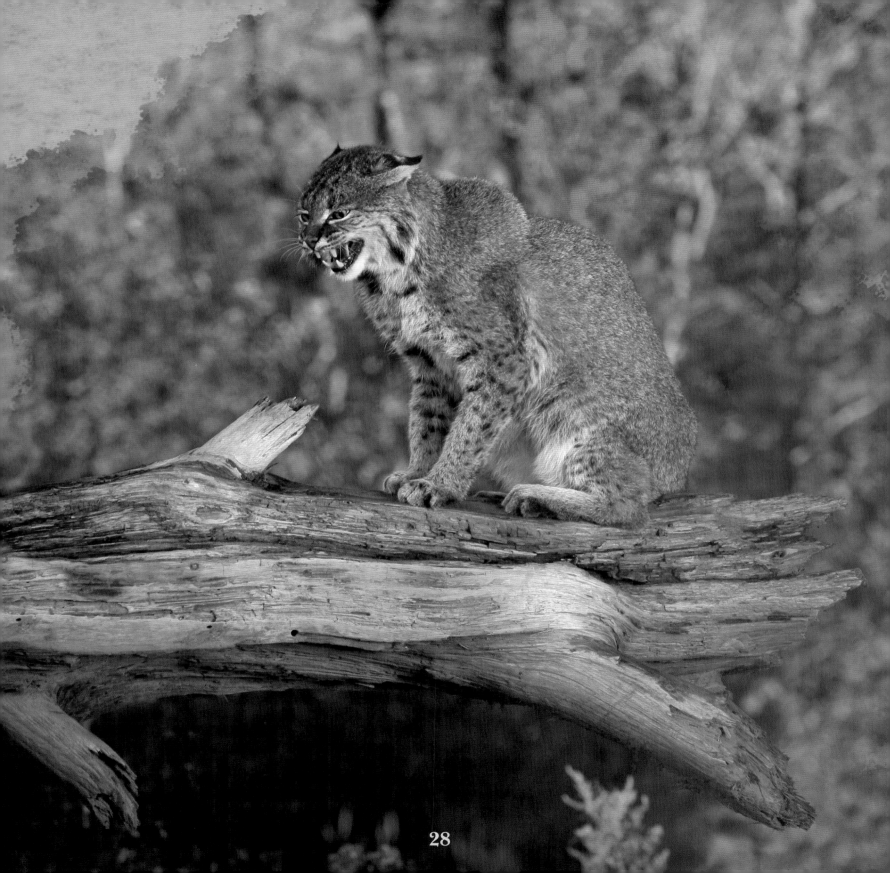

Finally, Ginger and Rusty come to the edge of a lake. In the middle of the lake is a small island. "I bet that bobcat can't get to us there!" says Rusty.

"What's that sparkling at the edge of the island?" asks Ginger.

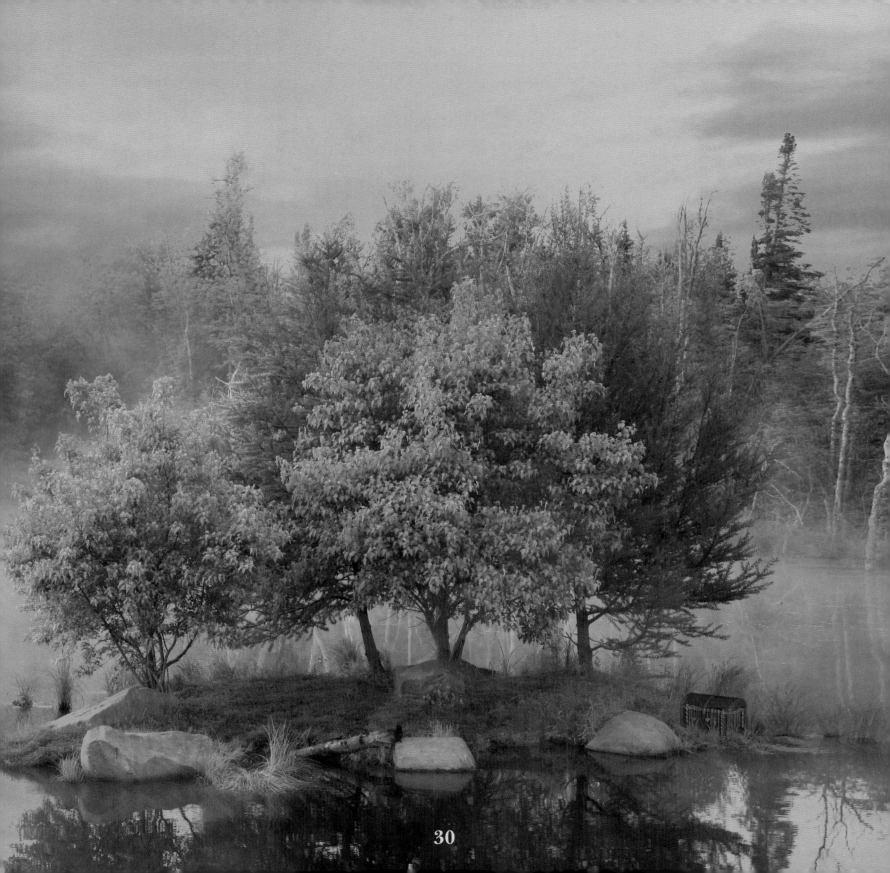

"I wish we could get a closer look," says Rusty, "but we're not supposed to swim without Mom and Dad, and I'm pretty sure foxes can't fly."

Just when Rusty and Ginger are about to give up,
they hear a familiar voice.

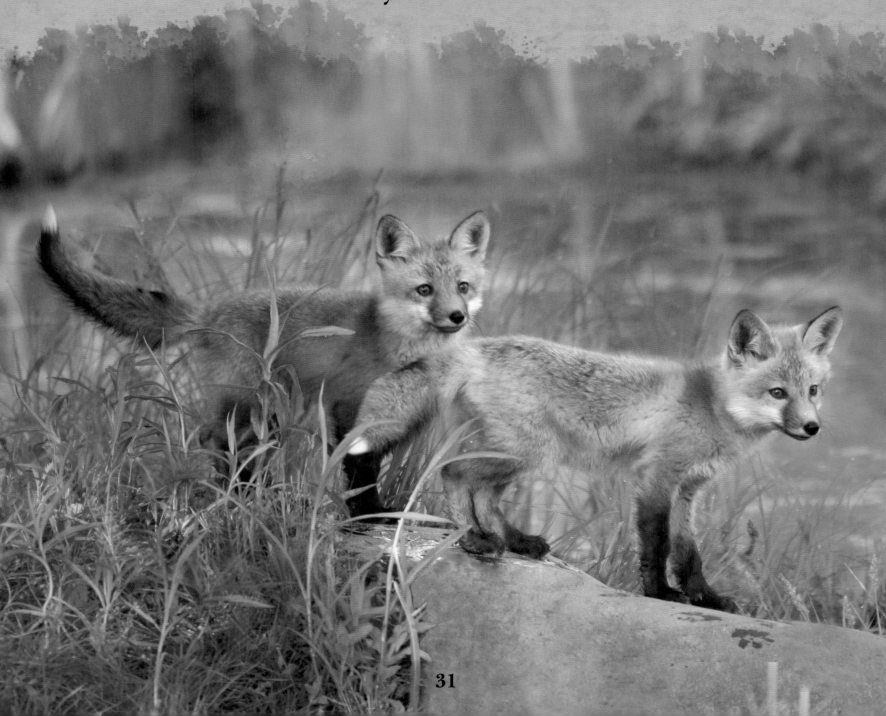

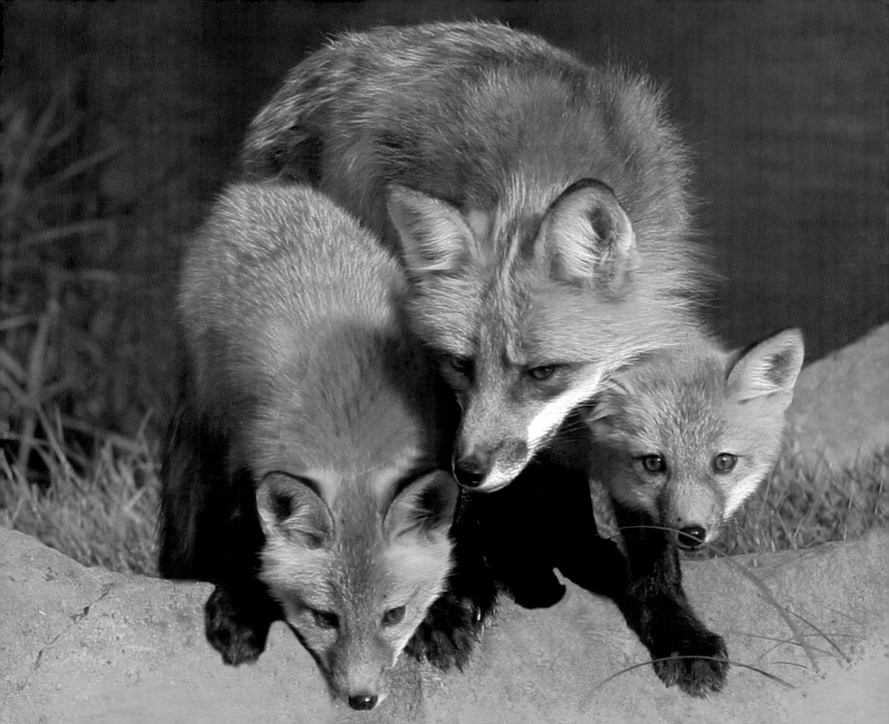

"Hey pups," says Dad, squeezing between them, with Mom close behind. "What are we looking at?"

"There's something sparkly over there on that island," says Ginger, "and Rusty and I can't figure out what it is from so far away."

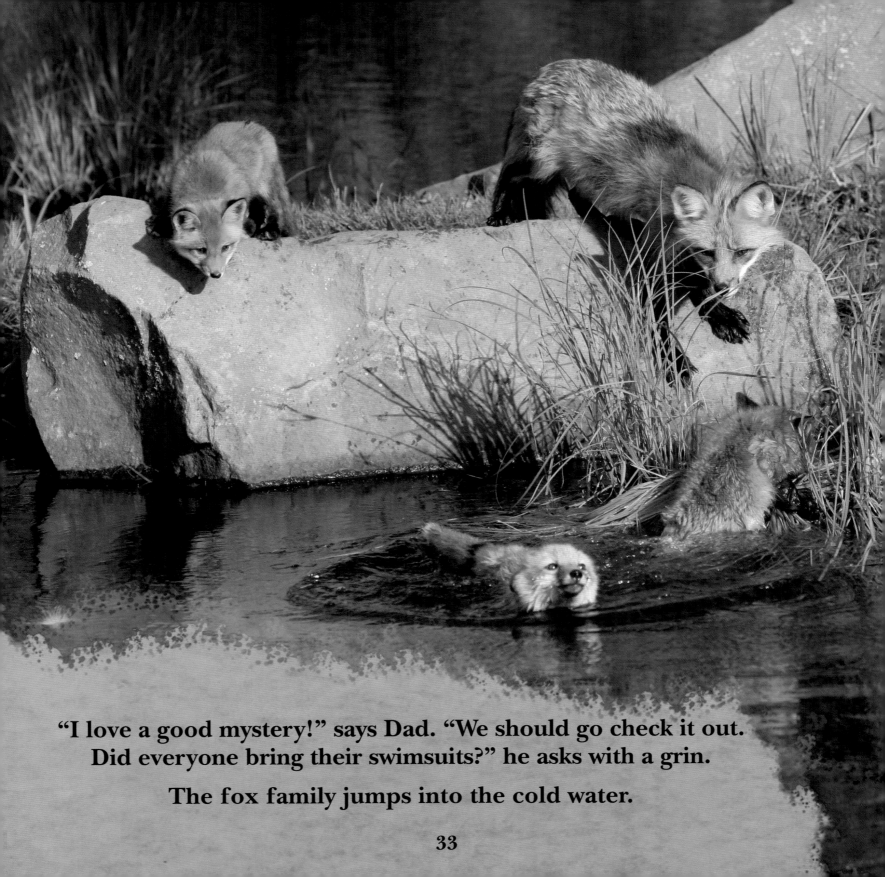

"I love a good mystery!" says Dad. "We should go check it out. Did everyone bring their swimsuits?" he asks with a grin.

The fox family jumps into the cold water.

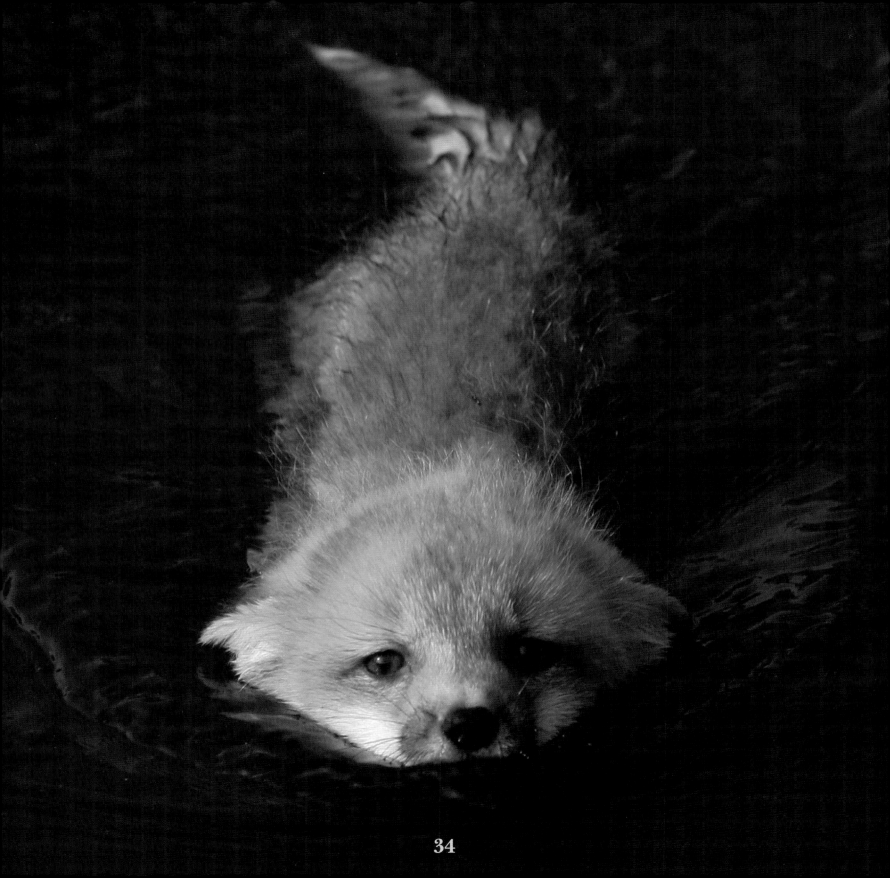

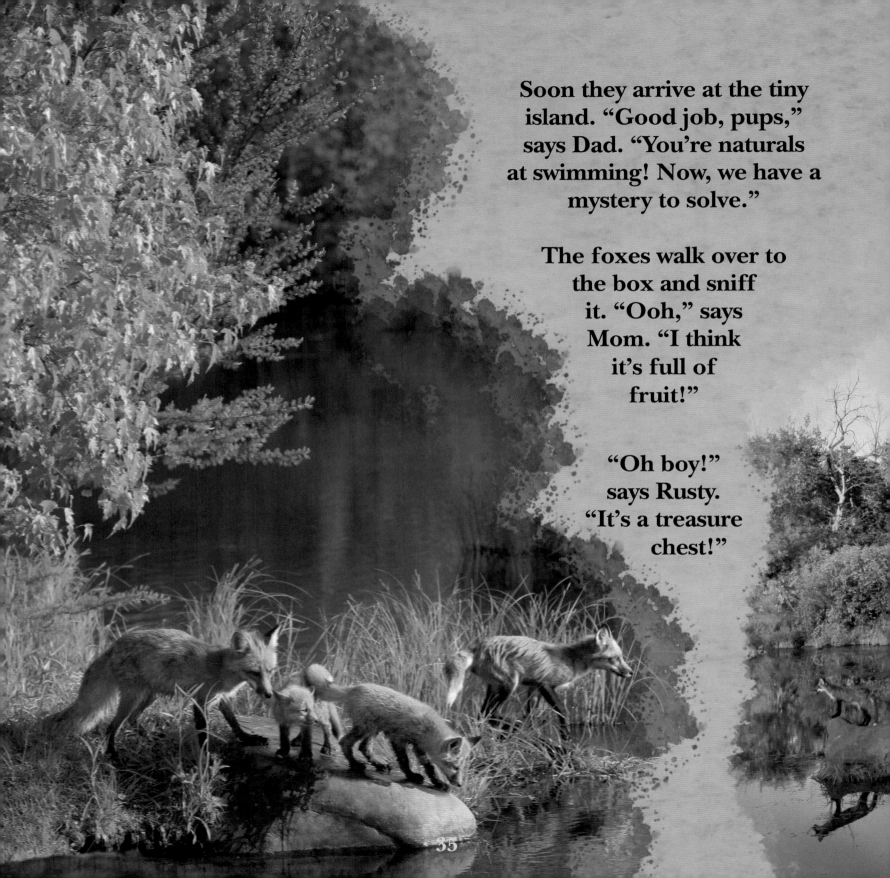

Soon they arrive at the tiny island. "Good job, pups," says Dad. "You're naturals at swimming! Now, we have a mystery to solve."

The foxes walk over to the box and sniff it. "Ooh," says Mom. "I think it's full of fruit!"

"Oh boy!" says Rusty. "It's a treasure chest!"

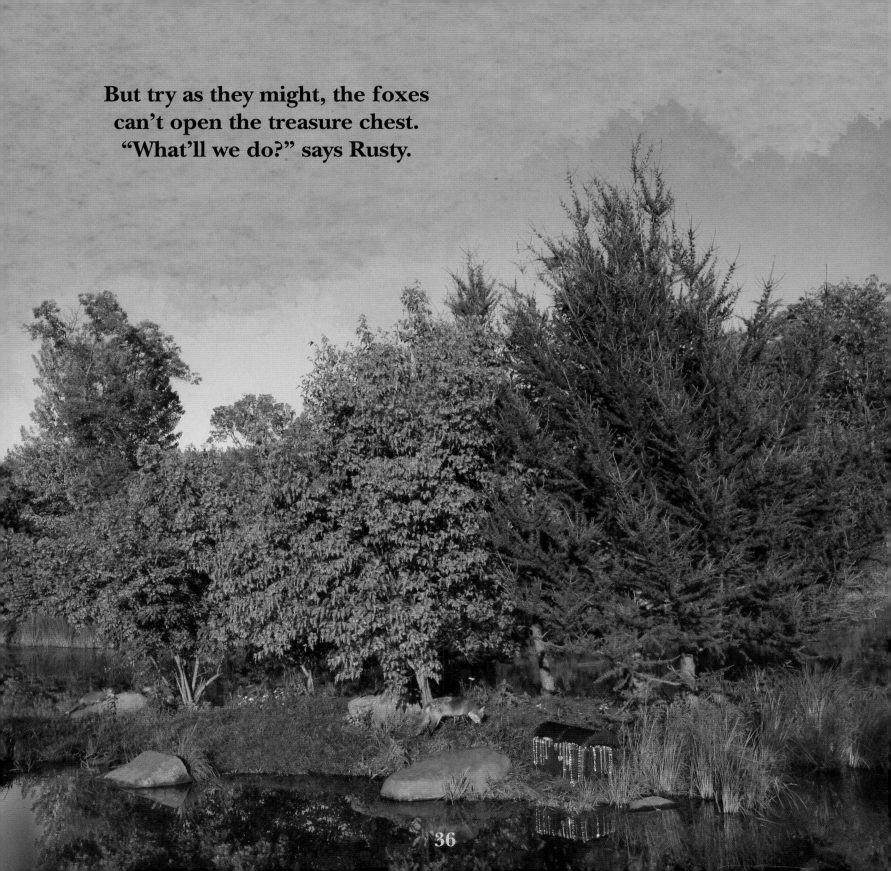

But try as they might, the foxes
can't open the treasure chest.
"What'll we do?" says Rusty.

36

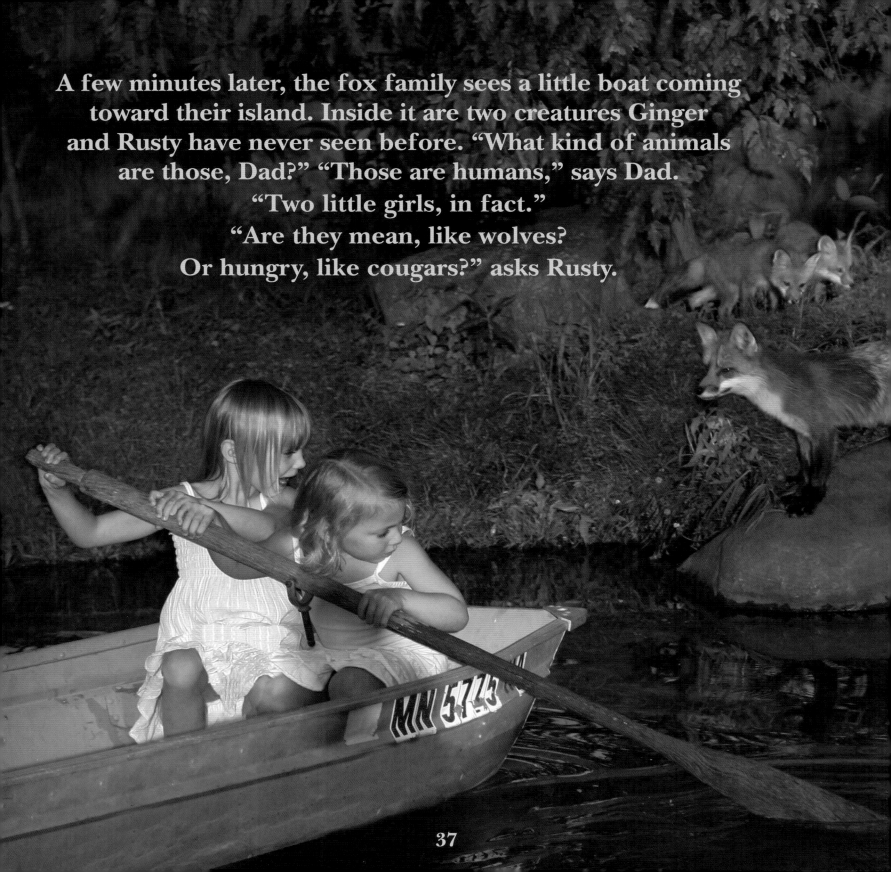

A few minutes later, the fox family sees a little boat coming toward their island. Inside it are two creatures Ginger and Rusty have never seen before. "What kind of animals are those, Dad?" "Those are humans," says Dad.
"Two little girls, in fact."
"Are they mean, like wolves?
Or hungry, like cougars?" asks Rusty.

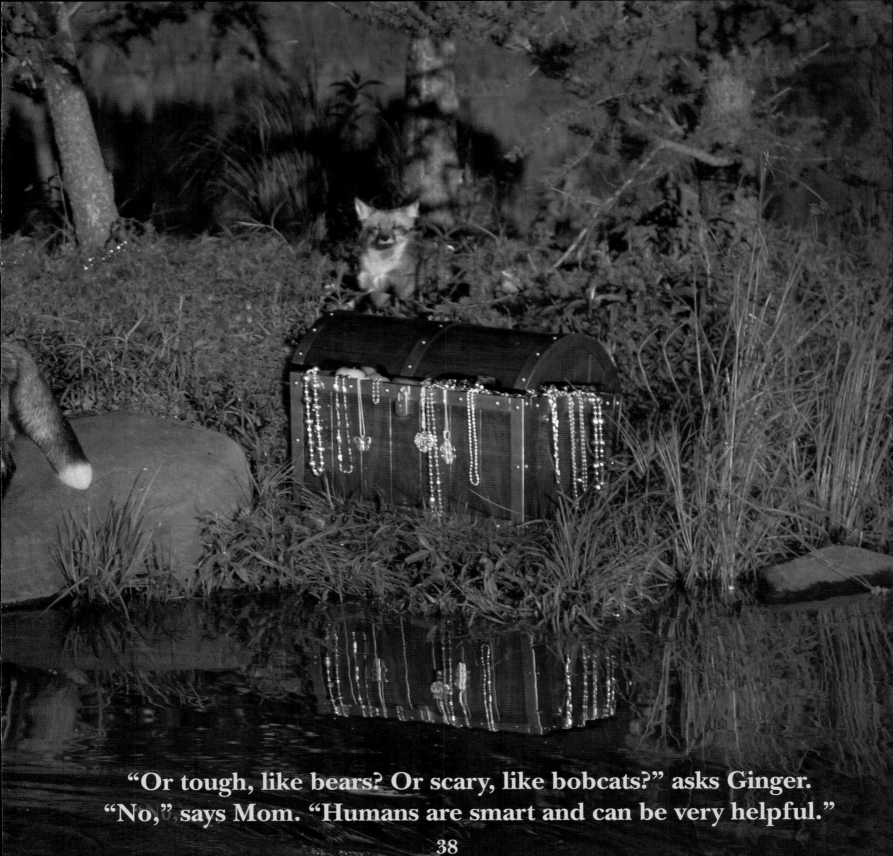

"Or tough, like bears? Or scary, like bobcats?" asks Ginger.
"No," says Mom. "Humans are smart and can be very helpful."

38

Did you know that Humans...

Can run 15 mph, though the best athletes can reach speeds of 26 mph

Can watch cartoons and football games on TV

Can think

Can talk

Eat with forks and spoons

Have 206 bones in their bodies as adults

Can weigh, on average, 175 pounds

Work on computers

Can do cartwheels

Can tell jokes

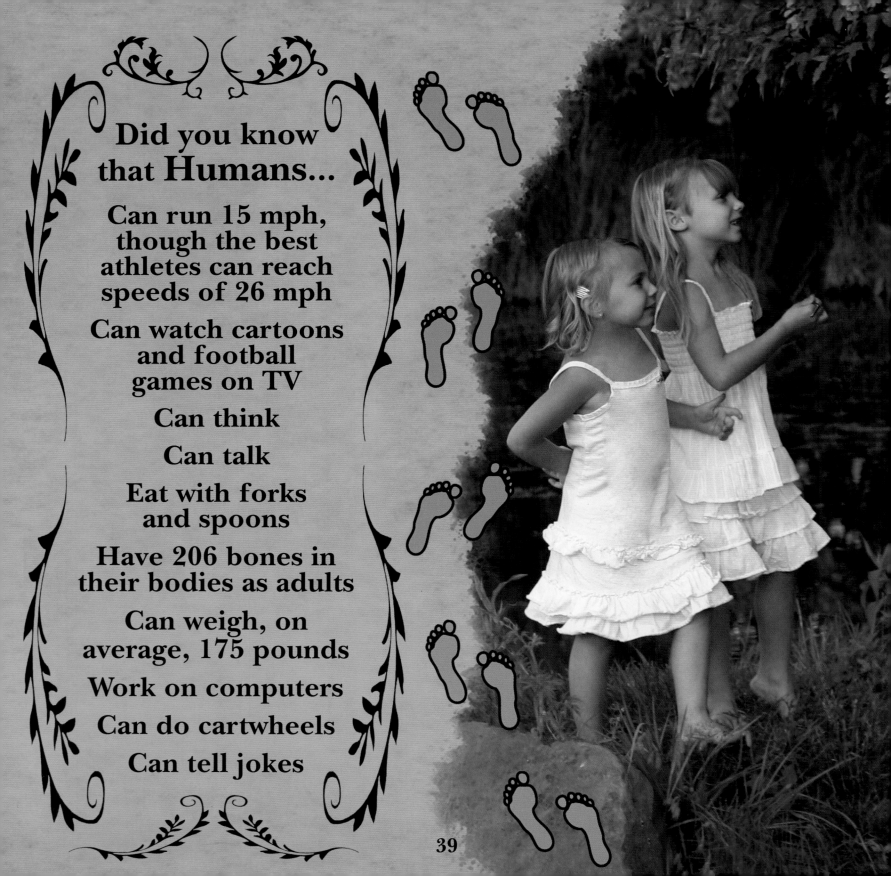

Ginger and Rusty are very happy to see the little girls. "Maybe they can help us open the treasure chest!" says Ginger. The foxes lead the way to the chest.

"Look, Emma!" says the smaller girl. "It's a treasure chest! And I think they want us to open it."

"On the count of three, Sophia," says the bigger girl. They give a mighty tug, and it pops open. As Emma and Sophia look in the treasure chest, they find more riches than they could have dreamed of—gold coins, diamonds, beautiful jewelry, and tasty fruit.

Since the foxes found the chest and the girls opened it, they share the treasures inside. Mom picks up the fruit with her mouth, and the girls feel very lucky to have found the wonderful treasure.

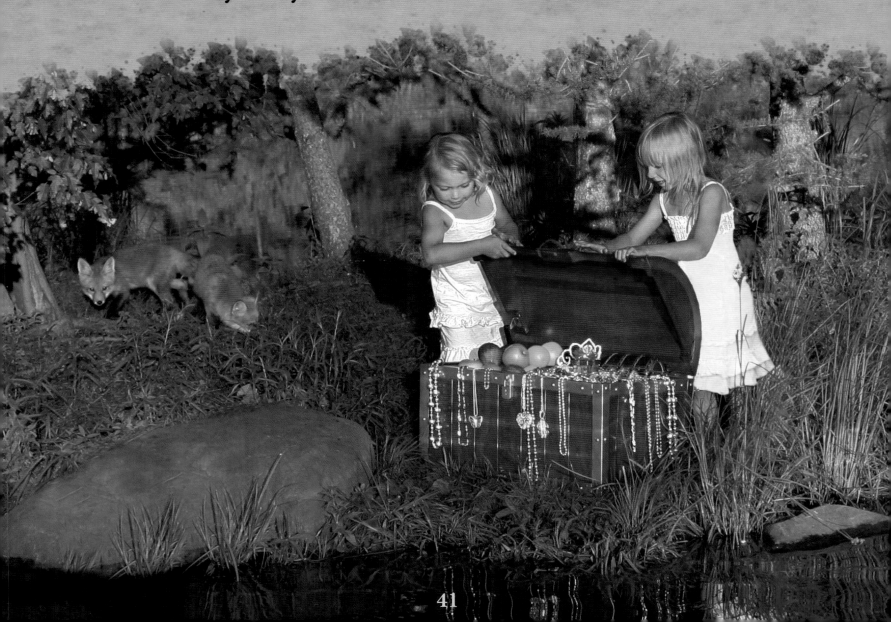

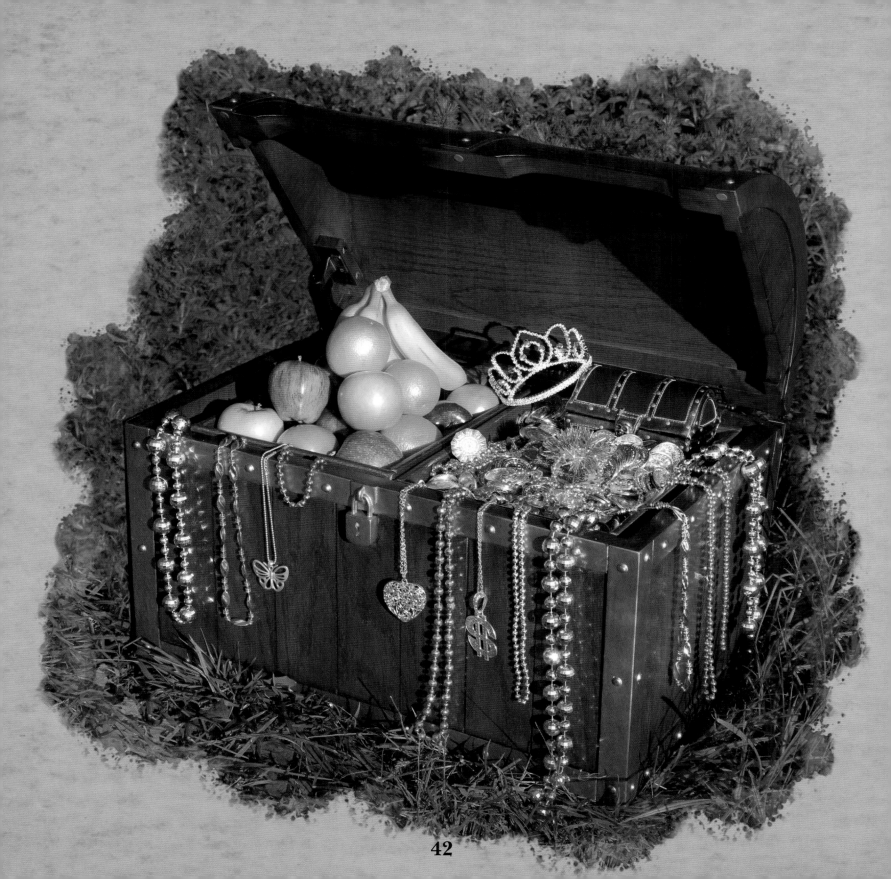

Emma enjoys a stroll through the lake while Mom licks her lips after eating the delicious strawberry.

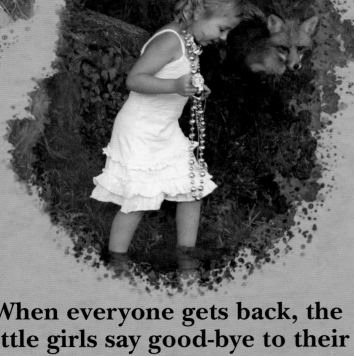

Emma has fun playing hide-and-seek with mother fox.

Emma looks for the perfect earrings for her outfit, while Mom takes bites of a juicy strawberry.

When everyone gets back, the little girls say good-bye to their new friends. "We are so glad that your entire fox family is safe on Treasure Island," says Emma happily.

"And we're glad that you decided to share your treasure with us," says Sophia. "We've decided we want to share, too."

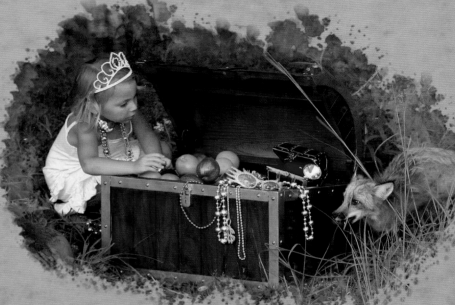

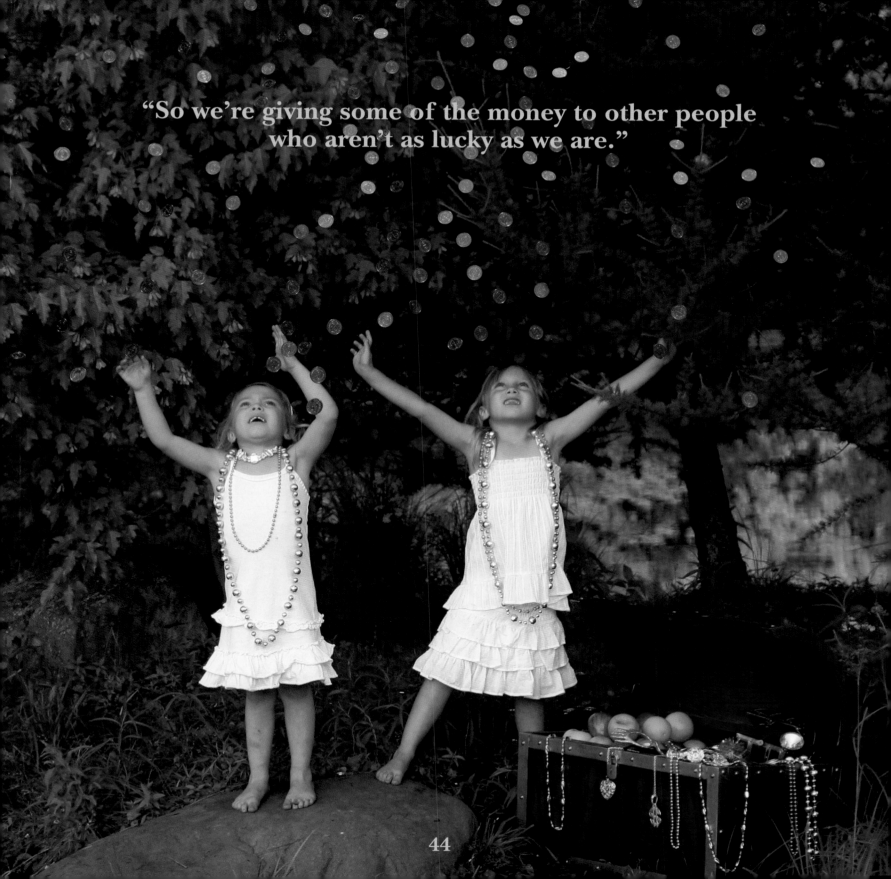

"So we're giving some of the money to other people who aren't as lucky as we are."

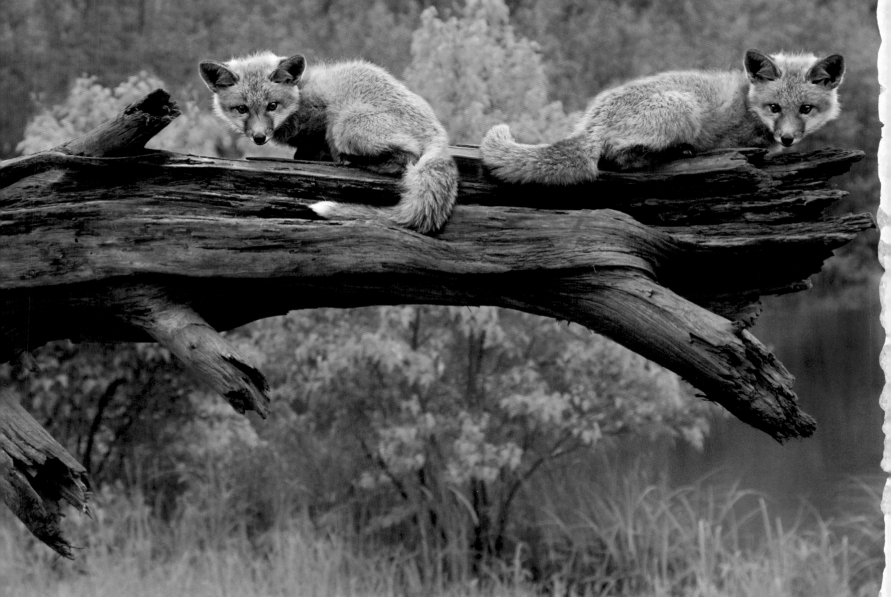

Since this is the back page of the book,
it is appropriate for Ginger and Rusty to tell
you back-to-back, how much they enjoyed
sharing the adventures in this book with you.

Ginger and Rusty are now thinking of all the exciting
adventures that tomorrow will bring.

45

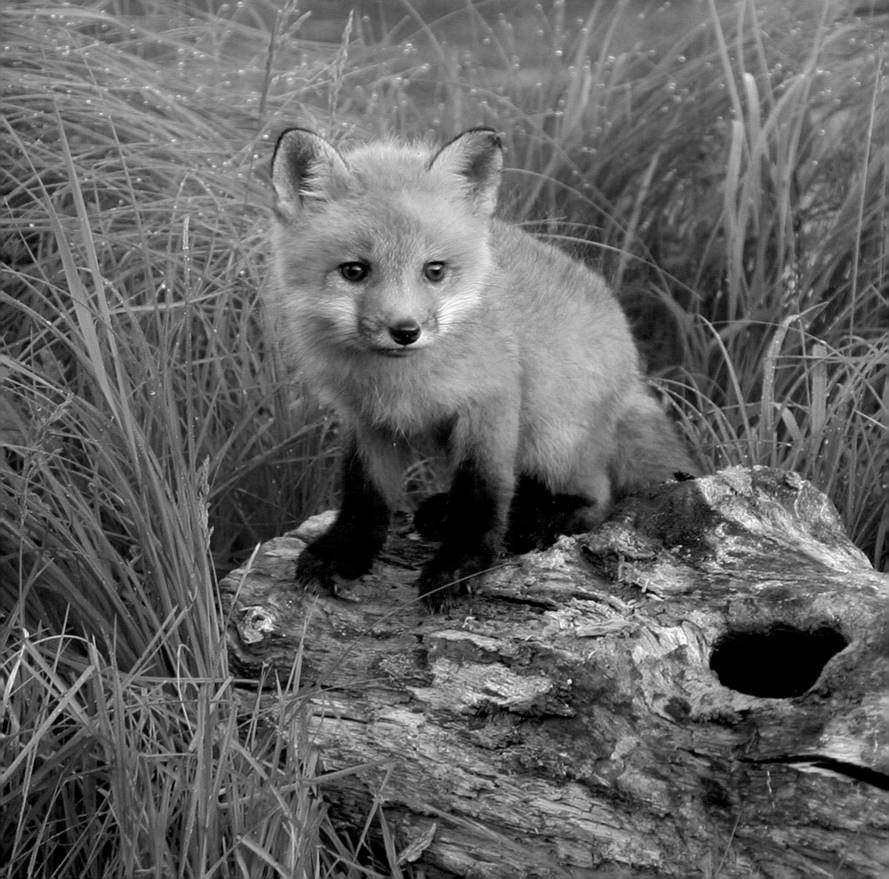